PIERO FORNASETTI

A CONVERSATION BETWEEN
PHILIPPE STARCK AND BARNABA FORNASETTI
BY BRIGITTE FITOUSSI

ASSOULINE

Endpapers: "Jerusalem" wallpaper designed by Piero Fornasetti for his home, 1950.
Right page: "Serratura": keyhole on black ground.

© 2005 Assouline Publishing
601 West 26th Street, 18th floor
New York, NY 10001, USA
Tel.: 212 989-6810 Fax: 212 647-0005
www.assouline.com

Translated from the French by Charles Penwarden.

Illustrations: © Fornasetti.

ISBN: 2 84323 679 7

Color separation: Gravor (Switzerland)
Printed by Grafiche Milani (Italy)

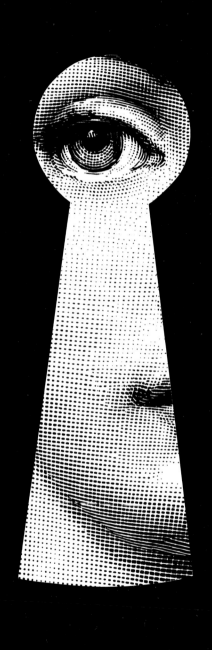

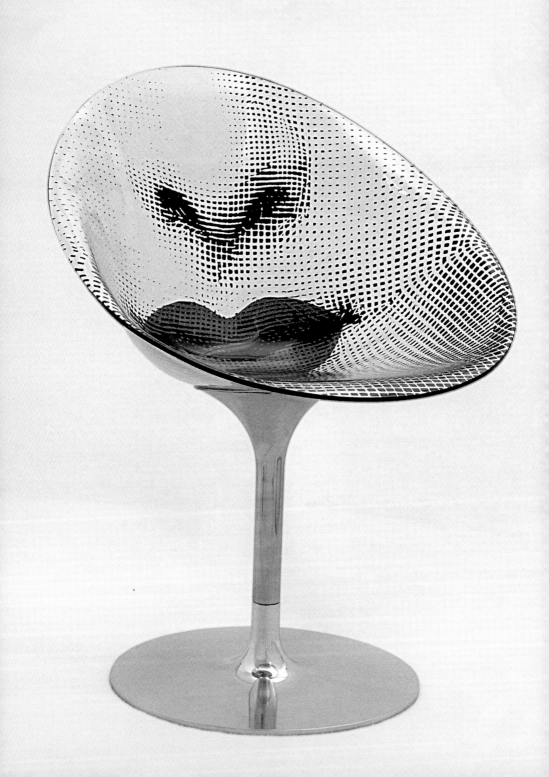

Fornasetti's Secret

A singular designer, craftsman, poet, and marvelous draftsman, Piero Fornasetti (1913-1988) stands apart in the world of Italian designers as one of the most prolific decorative artists of the twentieth century. Mixing both art and craft, his rich work is the fruit of an unbounded imagination and a real virtuosity at telling stories through furniture, objects, and decoration.

The diversity of his surreal motifs, many of them tromp l'oeils, are living proof of a very special and fantastic talent, founded on the key virtues of precision, humor, and elegance. Fornasetti's inventive magic allowed him to blend imaginary extravagance with peerless craftsmanship, to mix techniques and materials with supreme liberty, and thus produce a unique body of work.

Born in Milan in 1913, Piero Fornasetti was a painter, sculptor, set designer, and printer of art books. Over the years, he dreamt up more than eleven thousand objects, designed sets and costumes, and organized numerous exhibitions around the world.

Most of his work, which he first exhibited at the Milan Triennale in 1935, was significant. His creative life was also considerably

"Eros," prototype of the Philippe Starck chair
for Kartell with an intervention by Fornasetti, 2005.

enriched by his professional relationship with Gio Ponti, for whom he worked from 1944 onward. Ponti gave him numerous commissions and, especially in the beginning, stimulated his inventiveness in terms of both decoration and techniques of application.

More than fifty monograph shows have paid tribute to his work beginning with Geneva in 1944, all the way to the most recent, posthumous one in Los Angeles in 1998. The first Fornasetti monograph was not published until 1991, a few years after his death, on the occasion of a major retrospective put on by the Victoria and Albert Museum in London. Fornasetti died in 1988, at the age of 75, after being admitted to a hospital for a minor operation.

The Fornasetti studio was given a new life when Piero's son, Barnaba, took over. He is perpetuating the family's artisanal tradition, and has delved into the archives, resuscitating many of his father's designs and, as if by magic, applying them in all sorts of new ways. Barnuba has thus made it possible to create a licensing system for various commercial sectors, allowing for the production of branded ties, umbrellas, leather goods, furnishing fabrics, cloths, lighting, ceramics, decorative objects, furniture, and jewelry.

And so the twenty-first century sees Fornasetti making a fresh start as, thanks to Piero's heir, the heritage has been enriched by a new collection of furniture and objects (lamps, glasses, tables and chairs) designed with the English architect Nigel Coates. This collaboration, the first since Ponti's day, represents a new phase for the Immaginazione studio, which Fornasetti plans to continue by working with other talented designers.

One of these could well be Philippe Starck, the famous French designer, whom Barnaba Fornasetti holds in great esteem. In the informal conversation between the two men that follows, Stark describes, with a mixture of modesty and verve, his own vision of the great Italian master.

Barnaba Fornasetti: I know how much you admire Piero Fornasetti. Several of his chairs are used in the luxury hotels you designed. It must have been these affinities that gave me the idea to have this conversation with you. I thought you would understand Fornasetti better than most. And I was also very eager to meet you.

Philippe Starck: First of all, I would like to tell you a story. I must have been about 25 when I started working with Italian design firms. One of the designers, who later became a very important partner and also a great friend, was Enrico Astori, the head of Driade. One day, he and his wife, Adelaïde—they thought very highly of me—were really keen to introduce me to someone. Well, I was a young man and not at all thrilled by the prospect, but they insisted, "You have to meet this person, we love the man, and what he does." I turned them down three or four times, but they finally managed to take me to this little street in Milan where there was a poky little store, full of these

really weird things. They were so proud to introduce me to this artist and poet that they knew. They were also very happy for me to discover this man and his world so that I could appreciate it as well. The man was your father, Signore Fornasetti.

B.F.: Was it a gallery or a store?

P.S.: It was in a tiny little street—Via Brera, I think. A really dark boutique with one or two windows.

B.F.: That was my father's last boutique.

P.S.: Anyway, I said hello to the man, checked out the objects—just a quick glance, though. To me it was all really boring and of absolutely no interest. In fact, after a quick look around and few words, I said, "Okay, let's go." The Astoris were really distressed by my reaction, because they thought I was an intelligent young man with good taste, when actually the person they had before them was a stupid teenager who couldn't care less [laughs]. I do believe they were genuinely saddened. And so, after that, I got on with my life as one does, and, gradually, much later on, I started saying, "I love that object, and that other one, too. Who made them?" And the answer was, "Fornasetti." And I thought to myself, "Fornasetti? Fornasetti…" It rang a bell [laughs]. I only realized how interesting his work was twenty years later. And that was my first encounter with Fornasetti.

B.F.: So, you met my father?

P.S.: Of course, we even spoke together a bit because I wanted to look polite in front of the Astoris.

B.F.: But was he amiable? I mean, he was a strange man, rather boorish and unmannerly—especially in that kind of situation.

P.S.: He was very amiable, impeccable even. In those days, I wasn't at all "cultural" or intellectual. I was out of all that. I wasn't anywhere, a bit like a newborn: completely void of culture. I was just focused on the future and technology and forgot all the rest. It took me nearly all my life—I'm not so young anymore, I'm 55—to realize that, deep down, I am purely "cultural." Even in terms of my personal life, particularly when meeting people from different cultures, I have seen how difficult it is to define myself and, there too, I have seen how fundamental the idea of culture was for me. When I think back to my youth and this meeting, I must admit that at the time I couldn't understand a thing. It's only much later that you realize that time is on your side and that, little by little, it helps us discover our affinities with culture. And that, in the end, discovering a body of work like Fornasetti's is something that helps you to know yourself better. It must be the most cultural body of work that I've ever seen, the only collection of objects that is poetic in three dimensions.

B.F.: This poetic approach is rather appropriate…

P.S.: It is poetry only because it defines itself solely in terms of cultural references. And what interests me most is its three-dimensional side expressed in two dimensions, which is what makes it so unique. It is purely graphic. You can always find objects that exist through their three-dimensional form, as you can find all kinds of paintings or drawings in two dimensions. With Fornasetti, the two dimensions exist through the graphic

form, but not only that: you can also see a third dimension, with the objects, and a fourth, with culture and memory, and a fifth— poetry. He had a knack for combining a three-dimensional object with a graphic design in two dimensions, which expressed in trompe l'oeil, by means of optical illusion, the perspective. It's fantastic. In fact, his objects, by their graphic qualities, seem to be basically pretexts for making a poem. That's why it's all so rare and so unique.

B.F.: I am aware of what you're explaining, but to me it seems natural because I know it from the inside. No doubt my father was more concerned than I am with the cultural aspect of his objects. I myself only learned this idea of culture from living alongside him. Now I think of myself more as the reflection of his incarnation. Reincarnation from father to son is not something you would usually say existed; perhaps it would be more appropriate to speak of an extension. But either way it's fine by me, I can live with that.

P.S.: I think that the mixture of dimensions enabled your father to create his own dimension. Today, when I say "It's very Fornasetti," people clearly understand what that implies. It has become an adjective.

B.F.: Do you think that Fornasetti is outside time, independent of styles?

P.S.: Yes, definitely, because, again, that mixture of cultural references makes him timeless.

B.F.: I sometimes think that you could put him on the same

wavelength as the new generation of artists, like DJs who mix together their sound tracks, and compare his body of work to a kind of sampling.

P.S.: That's an original comparison. Before telling you in greater detail about what I find fascinating in Fornasetti, I would like to tell you about my own approach. Professionally, I have two facets: I am a designer who draws objects, but, I am also an interior architect. When I have to design a public space, I use a very simple strategy, one I would describe as surrealist. As I often say, I am not interested in architecture or design in themselves. I think you can sometimes help people have a better life by creating places for them where they can be more intelligent, sexier, more brilliant, more in love, where they can dream more, have more imagination.

B.F.: My father aspired to the same thing—to the pleasure of everyday life, if you wanted to sum it up.

P.S.: Yes, doing things in such a way that people can be at their best. And if you want to achieve that in public spaces, like hotels or restaurants, then for me the easiest decorative strategy is surrealism. You can do things that are very small or very big, not put everything in its place, not think of the object that is most right for the place, that is most appropriate, or choose the most suitable material. That way you can make everything skewed and offer an immediate poetry. By that I mean that it immediately creates a kind of short circuit in the brain. Everything seems instantaneously bizarre, impossible. This is what I call the process of fertile surprise. Suddenly it gives you other ideas, it opens the mind. I don't have many tools available

to me with which to produce this surreal effect, but when I'm lost or just plain lazy, when I really don't know or my mind draws a blank, there is always my "Fornasetti secret formula" to get me going. Every object by Fornasetti, for example the teapot with eyes, which I have in my kitchen (and that I love), is an open door through which one is immediately sucked, like in Alice in Wonderland. And for me that's something you can't put a price on. Even after twenty years on the shelf, the teapot is a door that still opens. The magic still works. A Fornasetti object has the power to change the vibrations in a place, not because it's a handsome decorative object—it's nothing to do with that. You can be in a very handsome room, very well-decorated, with a really beautiful design, for all that it is still a room grounded in real life. But put a Fornasetti in it and it takes on a very different dimension, the dimension of dream. I still think that your father—and you yourself, now—had a kind of secret recipe, a special trick that I still haven't worked out.

B.F.: That's the first time I've heard anyone talk about Fornasetti's secret in such a way, not in terms of a technical interpretation. Everybody has tried to understand Fornasetti's secret, but always in terms of technique, the way he applied his drawings onto furniture or any other kind of surface. My father was a very talented craftsman, so this kind of question never interested him. He always used to reply that "Fornasetti's secret is the imagination."

P.S.: It's a mixture of imagination, culture and sensibility. Plus an incredible elegance, stemming from this tremendous freedom.

B.F.: Not forgetting the great rigor of the forms, inspired by

classicism and ancient objects. My father was particularly attentive to precision, to the positioning of his drawings.

P.S.: Maybe, if we had to define this secret recipe, we could say: poetry, discipline, and freedom.

B.F.: And also, always that touch of irony.

P.S.: If there wasn't that very sophisticated recipe, that mysterious something, if the magic didn't work, it would be totally ridiculous. But I have never heard anyone say, "It's kitsch." Never. On the contrary.

B.F.: I met the Italian designer Moschino not long before his death. He was a big fan of Fornasetti's too. He had the same kind of affinities as you, the same sensibility in his regard.

P.S.: You mention irony. Moschino reminds us that the roots of Fornasetti's work are more surrealist than ironic. It also suggests his rebelliousness. There was nothing bourgeois about him. I won't use the word provocation, because that always has negative connotations. Piero Fornasetti was an iconoclast, he created images by breaking up other ones. It's very important for a society, for a civilization, to have iconoclasts. If you don't break up images, nothing happens.

B.F.: Breaking images is something all great creators have in common.

P.S.: If Fornasetti's work is still valuable today, that's because it's like fine haute couture. Haute couture has always been

defined by this singular talent for stopping further down the line, as late as possible. By the freedom with which it says, "That's the way I think it, the way I dream it, the way I do it: that, and no other way." The finest haute couture—I am really talking about the past here (nowadays it's much more about marketing)—is a matter of pure imagination. It is the essence of creative freedom.

B.F.: Something indeed that the market doesn't call for.

P.S.: That is the secret of Fornasetti. It is the only "haute couture" producer of furniture and objects that I know.

B.F.: Like haute couture, our furniture is not for everyone. It is handmade, with real excellence in the materials, the finishing, the time spent making it. It is, in this sense, pure luxury.

P.S.: Fornasetti is above all luxury for the mind. That is why it is so unusual to find products that are as expensive but that never show it. It is true luxury—the luxury of intelligence. I hate all those things that are done just to justify a price, to show that it's expensive. With Fornasetti you can never reckon the price: poetry is priceless. You can't deny that it's expensive, there's such a high level of craftsmanship and it's difficult to make, but there is no venal value. Its elegance comes in part from that, this power in the intention. With Fornasetti you take a wooden box and inject the power of poetry into it and it becomes luxury. It's both modern and timeless.

B.F.: Not everyone can afford to buy Fornasetti, but everyone can appreciate it.

P.S.: It's so open, so free that there are lots of different levels of language and communication. A very cultivated person will appreciate the references, but someone else, who's just looking for something funny, will love it just as much. Even a child will love it. It's absolutely universal. Of course, to inherit a project as personal and sophisticated as this one is not easy. It's never easy to be "the son of..." I'm no specialist, but when you speak of reincarnation, I find the idea pretty appropriate. From the outside, nobody nowadays could tell the difference between you and him. Unless they knew your father.

B.F.: My father made all plans so that there would be someone to succeed him, perpetuate his techniques, continue everything he had set up. He was obsessed with the idea of longevity. And he wanted that person to be me. In the early days, I didn't work with him—we argued too much—but when I did join him, he taught me everything. I also learnt a lot inside the company, with the craftsman, the hands. I don't have any children and today it is very difficult to find someone who has the modesty to work with me under the Fornasetti name, among all our craftsmen. Whenever trainees spend a bit of time with us, their main concern is to impose their own vision.

P.S.: It's natural that a young person who hasn't done anything yet should want to distinguish himself and prove his own capabilities. Often, we think we know great artists such as Andy Warhol, Salvador Dali, and Magritte just from their icons. We think there's not much to understand, but when we go deeper into their work we see that it's much richer than we thought. It's rather similar with Fornasetti. When you ask for a description, the image that you get is often neoclassical. But, leafing through

the pages of your latest catalogue, you don't see many neoclassical images. It's always rather free and open.

B.F.: And yet, that in the end is what Gio Ponti criticized my father for. Their visions of modernity were too different.

P.S.: Gio Ponti must represent an important phase in your father's career.

B.F.: Gio Ponti is the one who, let's say, introduced my father to the world of the decorative arts. The idea of decorating Fornasetti objects originated with him. Gio Ponti designed for industry, and he was looking for a designer who was an expert at printing. My father, who was initially a printer, began painting and acquired an interest in all kinds of techniques when he was very young. In the early days, he printed mainly art lithographs. All the great painters came to his studio: De Chirico, Giacomo Manzù, and Lucio Fontana came to print lithographs, etchings, and books, too. He learnt a great deal about Italian surrealism. But alongside that, he also did his own work. And because he was an experimenter and fascinated by techniques, he made prints on silk, on scarves. He combined different kinds of techniques, stencils with lithography. Ponti had noted his technical skill, but also his imagination, his freedom of spirit. He asked him to experiment with techniques for applying decoration to the furniture that he wanted to produce industrially. He wasn't interested in the concept of the limited edition, but it was a simple illusion. The fact is that my father had a lot of problems with industry, they didn't understand his way of doing things. They took them—him and Ponti—for madmen, what with all those drawings of fish and other motifs on dishes, which they thought

were really off the wall. My father was soon forced to buy his own oven to make his ceramics, and to go to his own joiner to get his furniture made. His relationship with Ponti ended there. I found letters from Ponti to my father in which Ponti criticizes him for his old-fashioned decoration. Ponti wanted to move towards greater rationalism, he aspired to more modernity. And modernity didn't interest my father very much. He was self-taught and continued in the same direction for the rest of his life. After his death, I was the one who started changing things and issuing licenses. And even today I still work with this idea of the license, if only for products I can't make in the studio.

P.S.: What made you decide to join your father's studio?

B.F.: I started working with my father in the eighties. He died in 1988. But before that, I "was born with him in the studio," and "played" with the workers until I was 18. Then I left home because my relationship with him was complicated. I was a hippie, and so for me the end of the sixties, and even a bit earlier, was a time of rebellion. My father was an authoritarian type of person, very traditionalist, very Italian when it came to upbringing. And yet my rebellious behavior pleased him; inside, he was smiling at it. I am sure he was proud that I was like that, but maybe I wasn't sufficiently like that for his taste. He found me too conformist, not very different from the great majority of young people in those days, surfing on the wave of '68. He couldn't bear my long hair, because that was fashionable, and he'd always been against fashion. So I left, to get a bit of fresh air. I set up an underground magazine with other youngsters of the same age. I was the editor and the graphic designer, the others did the writing. Alongside that, I started designing fabrics with Ken Scott. He was

a very talented American fashion designer who lived in Italy. He died a little while before my father. Working with him was very instructive for me. In those days, everything revolved around the idea of not working with my father. It was impossible: he was at the height of his powers, very egocentric and extremely demanding. He asked so much of people. With him, it was twenty-four hours a day of total commitment. It was really excessive. I was too young, if anything I was more interested in music. After my experience with Ken Scott in Milan, I went to Tuscany, where I retired to the countryside to restore old farms. I also bought furniture from antiques dealers. I learnt a great deal there, too. For me, building a house oneself, understanding where you live, is the foundation of the profession now. Just as coordinating the work is fairly similar to managing a company. Then, at the end of the seventies, my father went through a serious crisis, which was partly economic. So he asked me to help. That was an act of great modesty on his part. For a tradesman like himself, it was very difficult to ask someone for help, especially me. But he also did it because I was his only son. I hurried to Milan to sort out the company, which really was in a bad way, and when I got there I started putting down markers to save the structure, and especially the archives. My father wasn't really old then, about 65, but he was tired. He had really thrown himself into what he did, and there had been too many disappointments, especially economic ones. The truth is that he wasn't a businessman. He was too much of an artist and had never managed to find honest collaborators able to understand him. His excessive egocentricity probably drove them crazy. So, bit by bit, I took control of everything. At first, I did it with him, even if it wasn't easy to get my own views across; I had to find the right way of dealing with him to make him feel important, to sweettalk him. He may have been hard, but he really

loved me. He would never have listened to anyone else. This collaboration lasted eight years, up until his death, and left a great feeling of emptiness, but also a lot of debts. After his death, I started to allow myself a few compromises (which he would have never accepted), setting up a few small licensing ventures. It started with ties, then went on to bathroom ceramics. Later, I established a license with Rosenthal porcelain, which my father would have loved because he had such an appreciation for quality. Rosenthal was his idea, I followed it up. Nevertheless, I realized that it was a mistake, my clients didn't want Rosenthal, but Fornasetti, handmade in the studio. They preferred dishes with an artisanal finish, and not necessarily as perfect or well-made as by an industrial company. Rosenthal also made strategic mistakes by positioning our dishes, not in their special collections, but in their general table services, along with pieces by Versace or other fashion designers. Some will say that that is probably where I started prostituting myself.

P.S.: I don't think so. You haven't fallen into the big-time business trap by reproducing his whole body of work. You never did that. The creativity and the energy have not subsided. The Fornasetti spirit lives on. It is still alive. The notion of product does not exist, just the idea of a product—of the mind applying itself. It's like the joke about the "tin of Scottish paint" with which you can paint directly in tartan. It doesn't exist, but it's a very funny idea. Making poetry out of almost nothing. And indeed, when you move away from your references a bit and create new pieces with Nigel Coates, it's very interesting. In fact, I am even a bit jealous.

B.F.: How do you see the future for Fornasetti?

P.S.: I never think of that, but it does open up a new territory. You could choose to be the talented keeper of the temple, you know how to do that. But you could do the same work with modern icons. Today, icons are so much a part of our society, they are so powerful and so dangerous at the same time. Behind each one, there is a war: a real war or a commercial war, the coming war or the last one. It would be amusing to destroy some of them. That would be your way of perpetuating Fornasetti's iconoclastic and rebellious spirit.

Speaking of which, I have designed lamps for Flos which should be shown soon in Milan. I revisited the iconic lamp typologies, in a very bourgeois style with gold decoration, and on them I printed a few stories about society, with powerful images of violence, of addiction. One could liken this to one of Fornasetti's little processes. It's very simple, the technology isn't perfect, but it's very funny. Having made so many new forms, I realize that I like to seek out iconic forms, onto which I then apply other messages. At last, I now realize that I am imitating Fornasetti [laughs].

B.F.: It's not so easy to create one's own collection. The problem of the Fornasetti studio is that it belongs to small-scale productive reality, one that, for lack of means, has never invested in advertising. Fornasetti communicates solely through events. The identity is not industrial. It's getting increasingly difficult to find craftsmen who want to make complex or sophisticated objects, lacquer for example, which is a dying art. Maybe in the future, for technical reasons, it will no longer be possible to make this chair or that wardrobe. "Made in Italy" production is becoming a myth, but I can't imagine transposing it into elsewhere very much.

P.S.: This is a unique case. Structurally, Fornasetti is a Freudian company whose whys and wherefores I couldn't explain. And in this Freudian society we have an Oedipal process. You ask me about the future and I answer that I don't know. If you want to be very free and use modern icons, then your culture, your natural elegance, your savoir-faire and your talent mean that you can now do that. Fornasetti is rich by virtue of its incredible diversity. You can imagine whatever you want; that is the privilege of freedom. It's up to you to invent your own style. So, good luck.

Conversation recorded by Brigitte Fitoussi
London, December 6, 2004

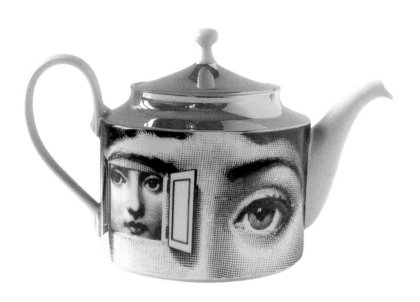

"Occhi": the eyes from the "Tema e Variazione" series on a teapot, 1989. © photo Ale Mosso.

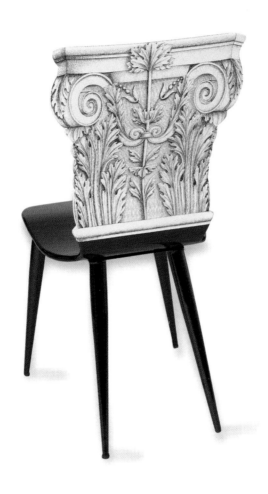

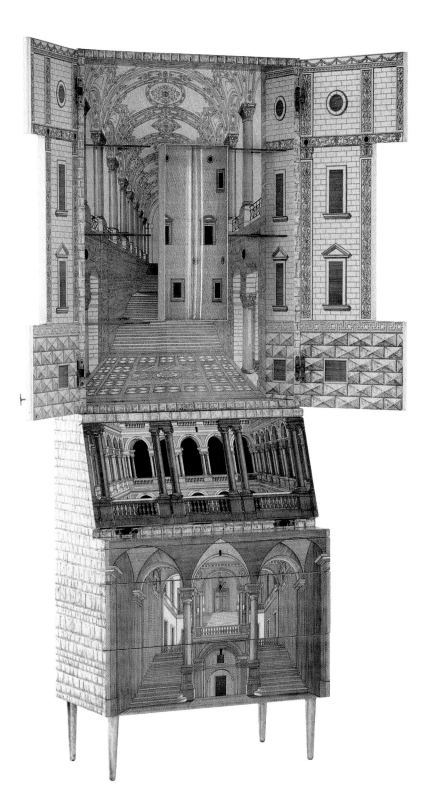

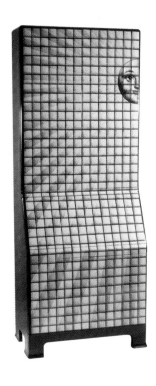
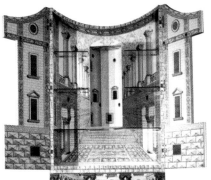
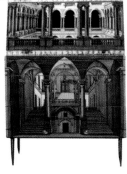
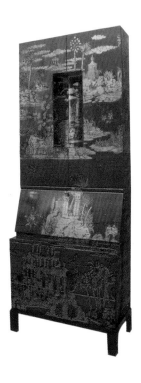
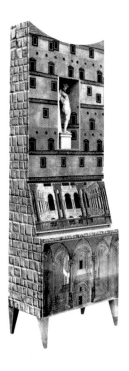
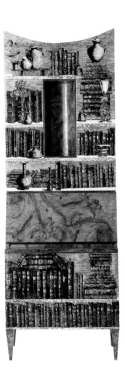
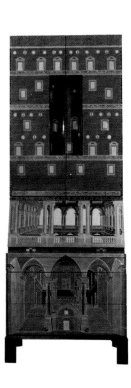
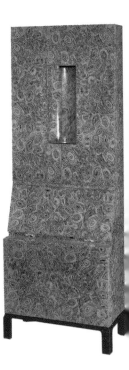

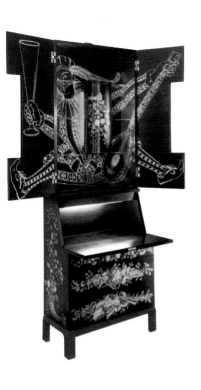
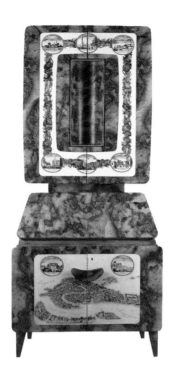
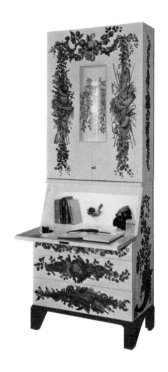
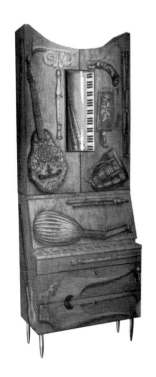
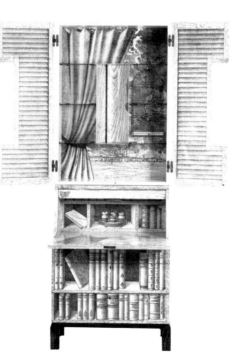
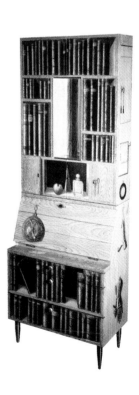

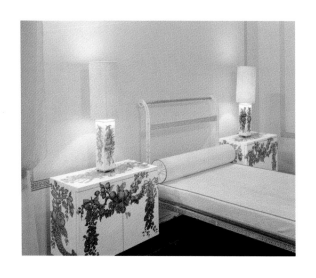

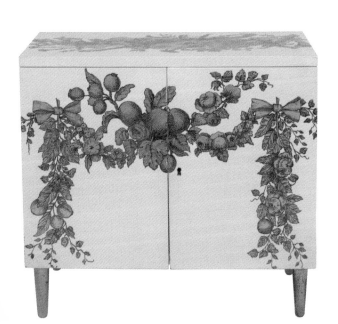

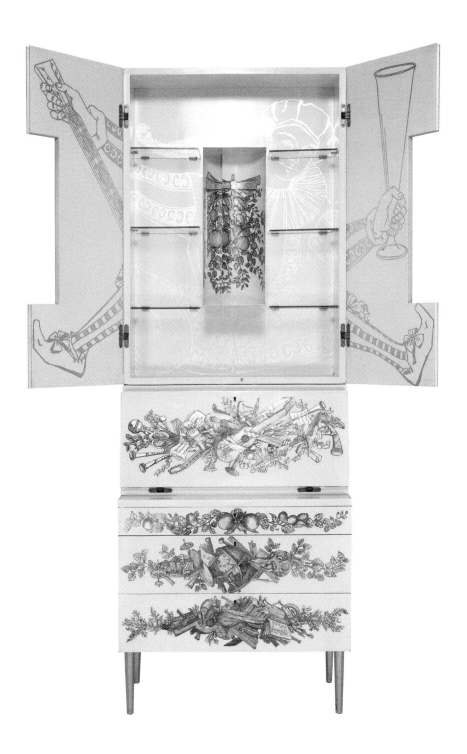

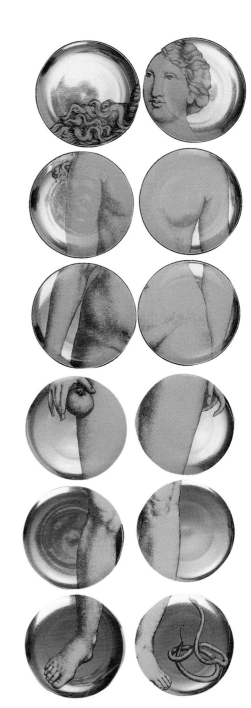

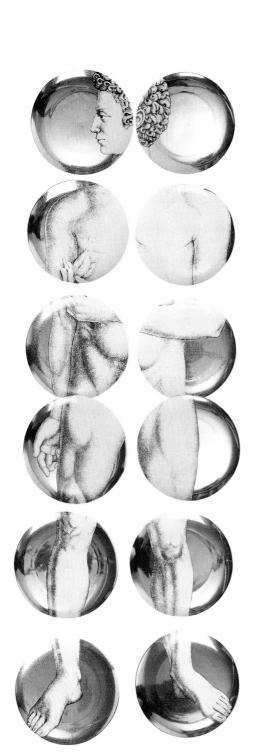

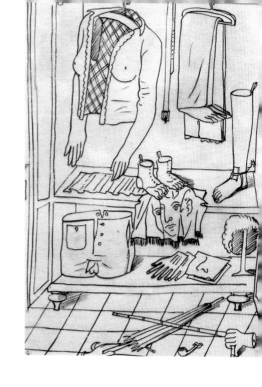

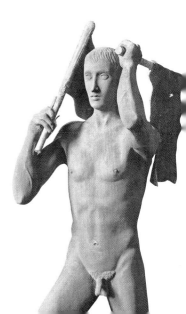

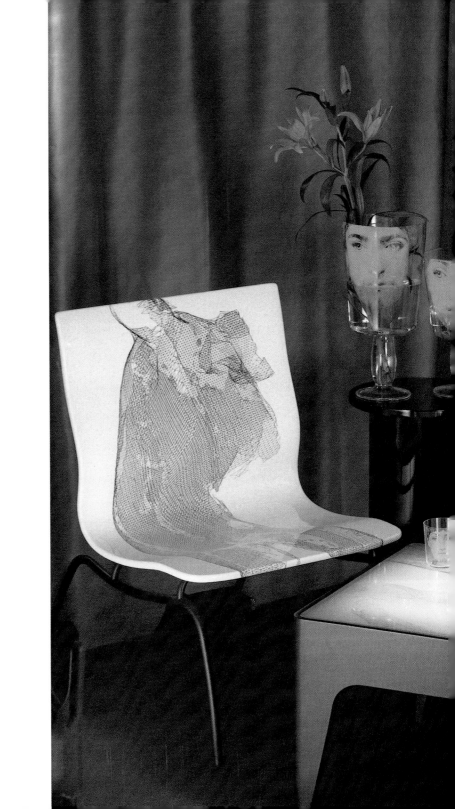

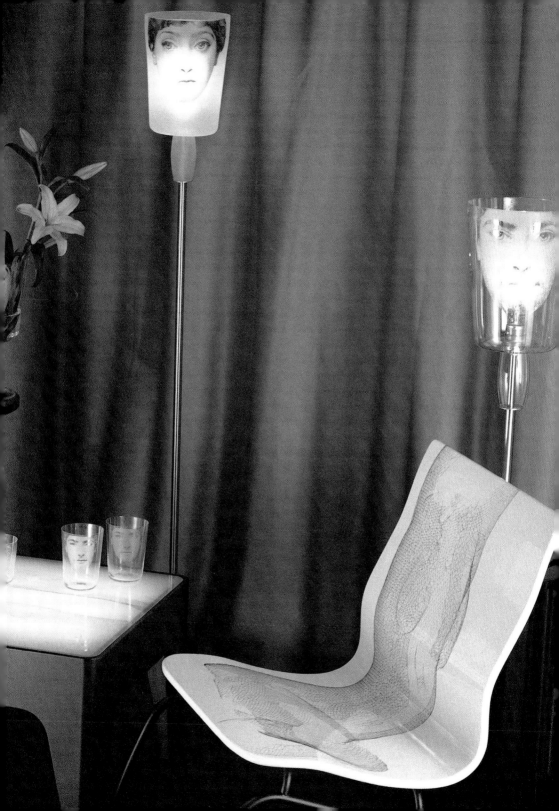

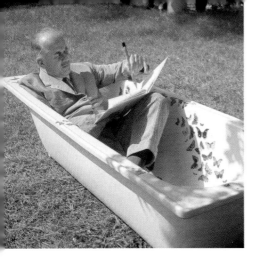
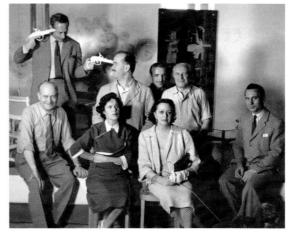

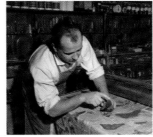
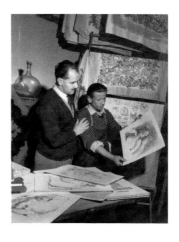
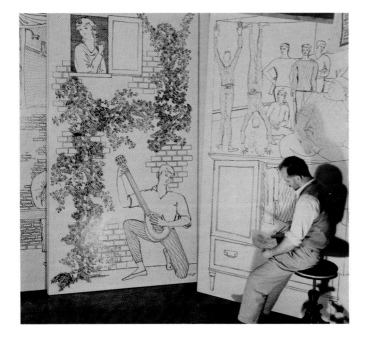
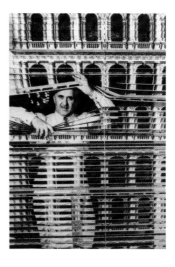

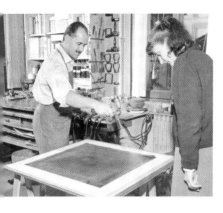
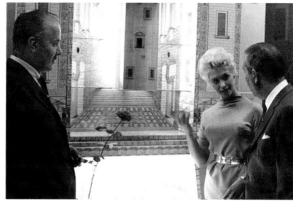
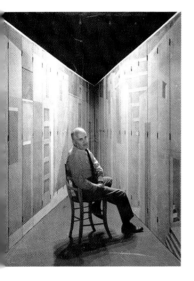

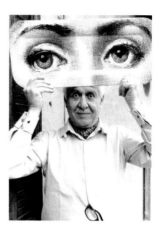

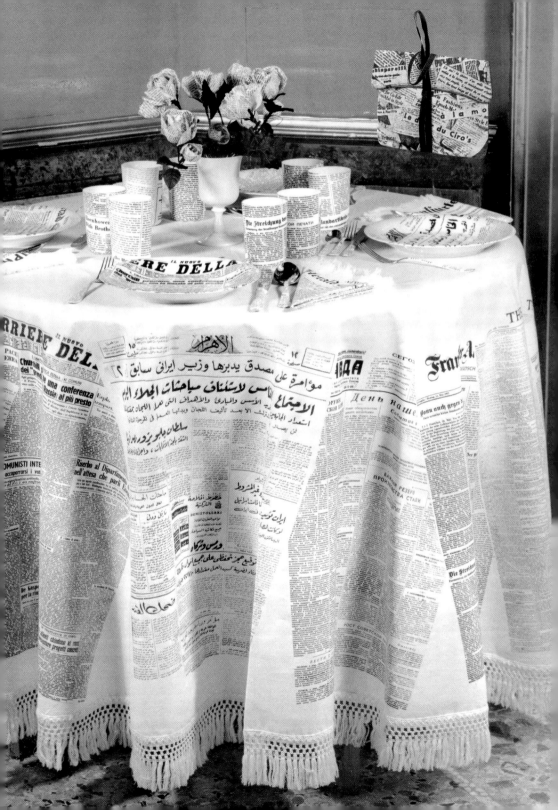

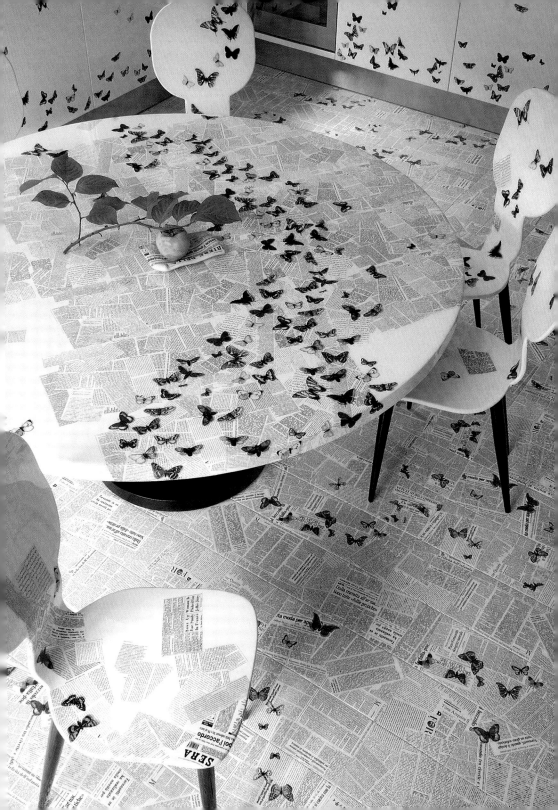

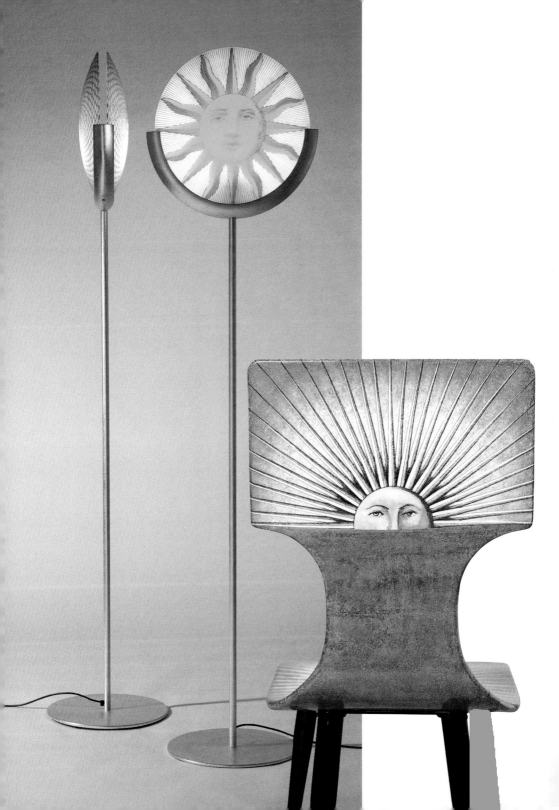

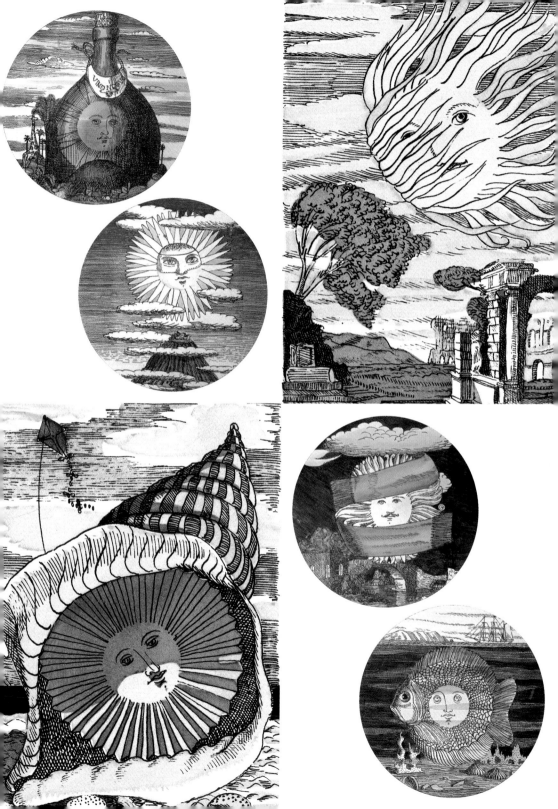

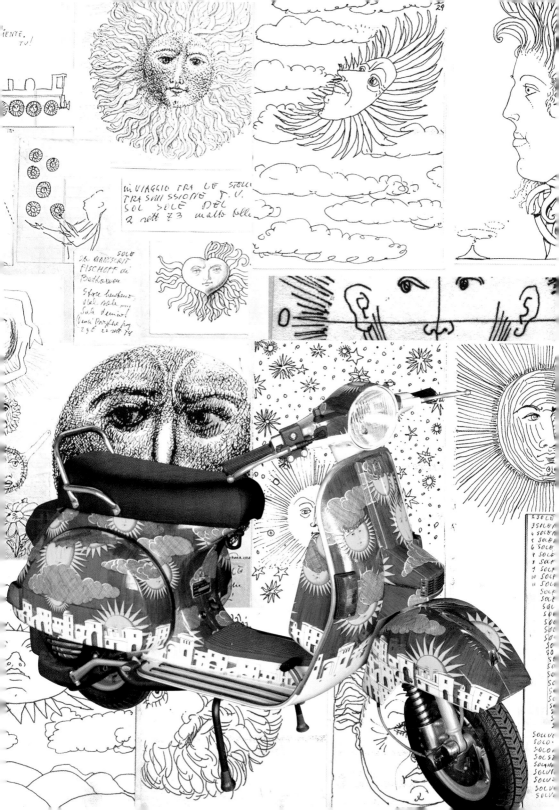

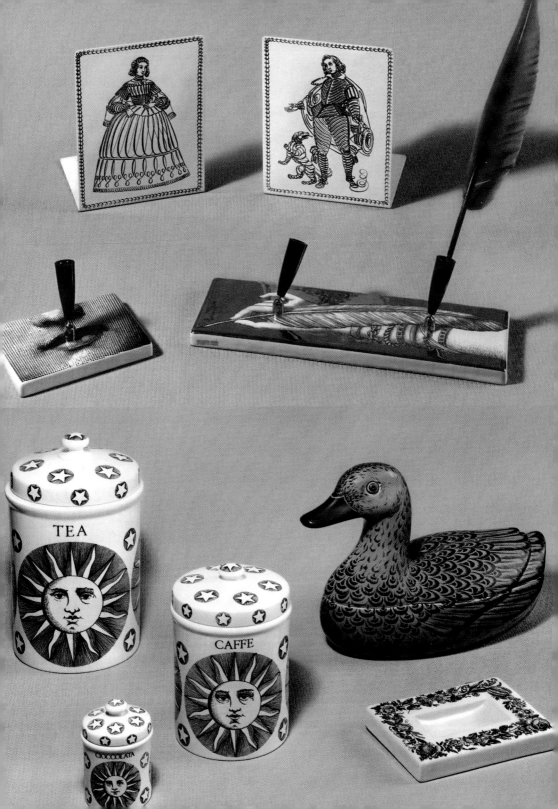

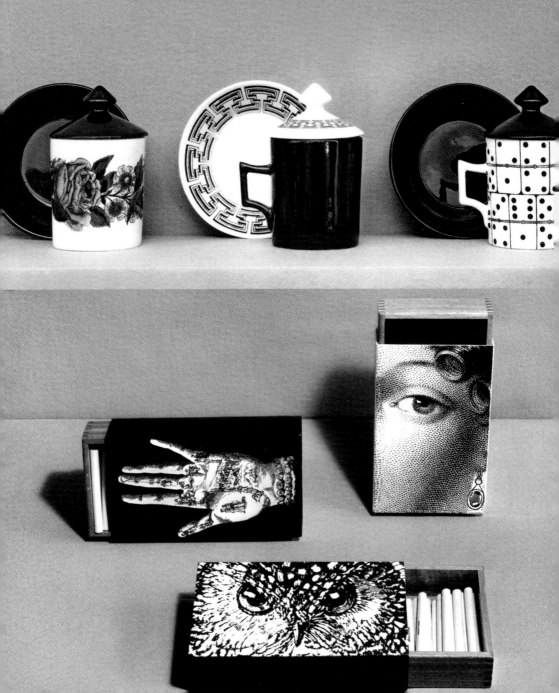

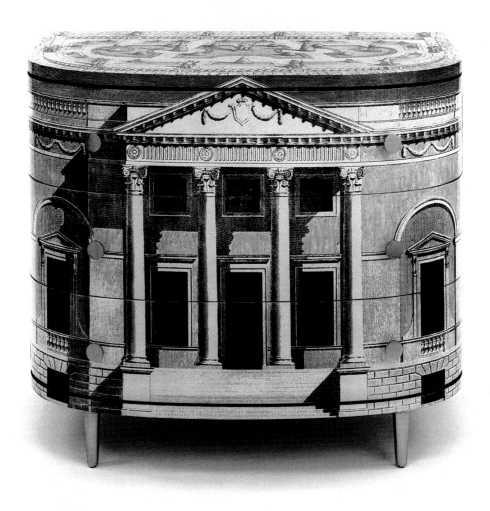

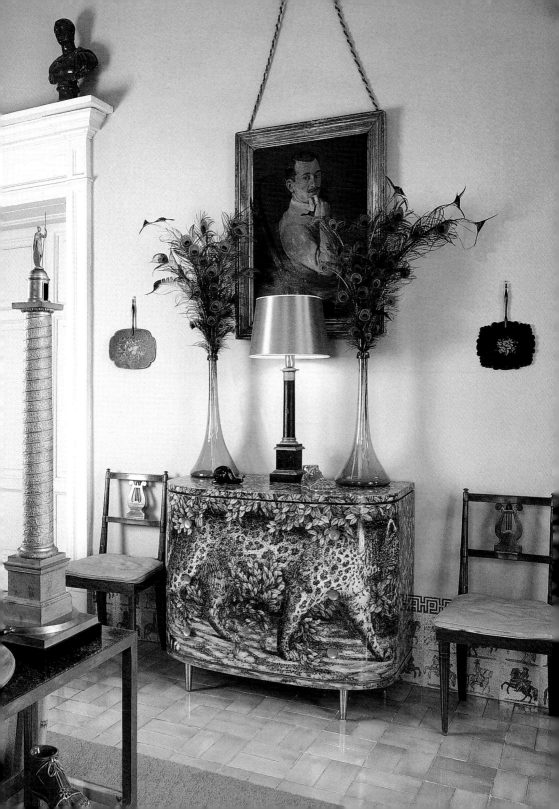

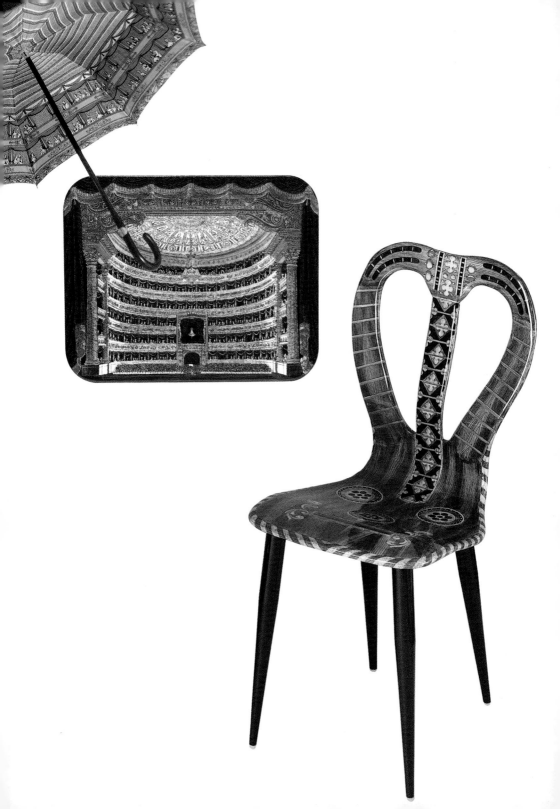

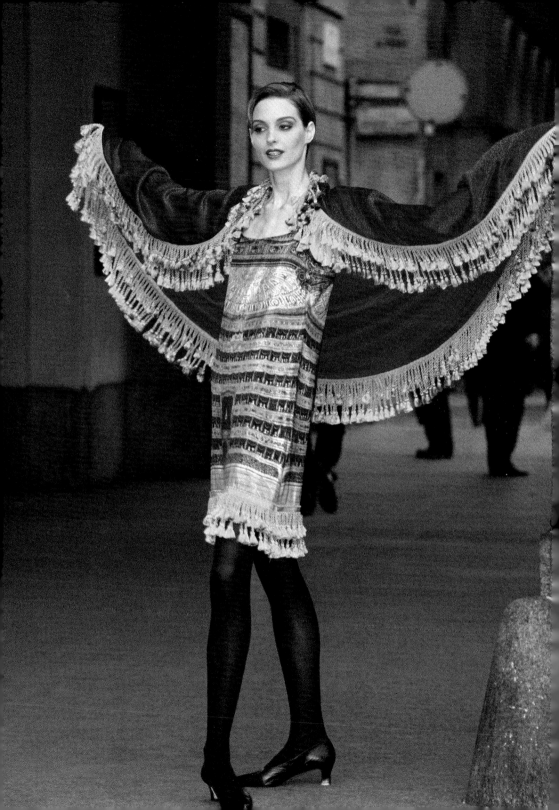

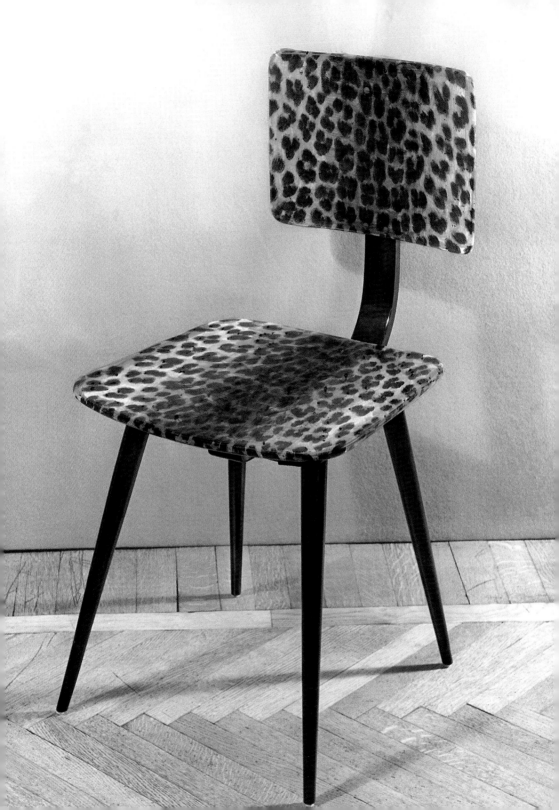

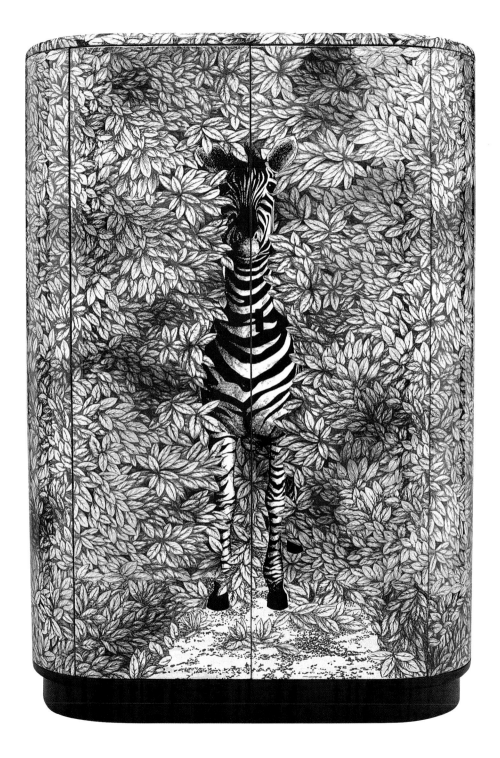

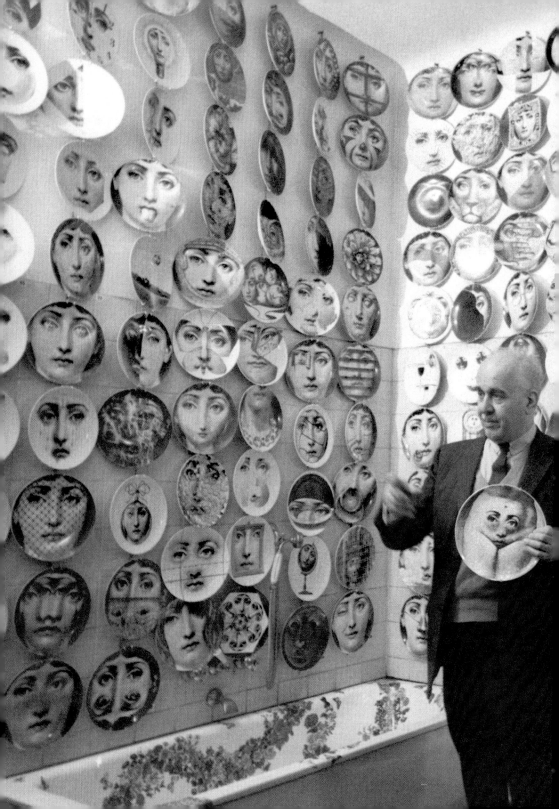

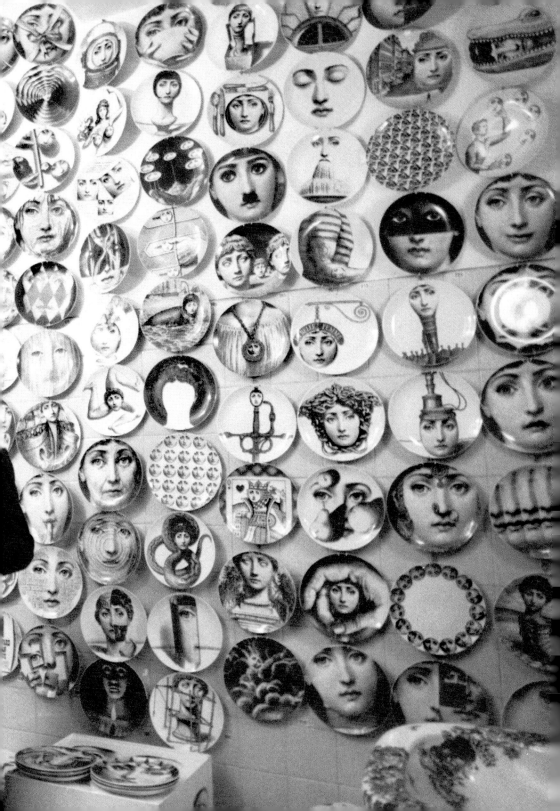

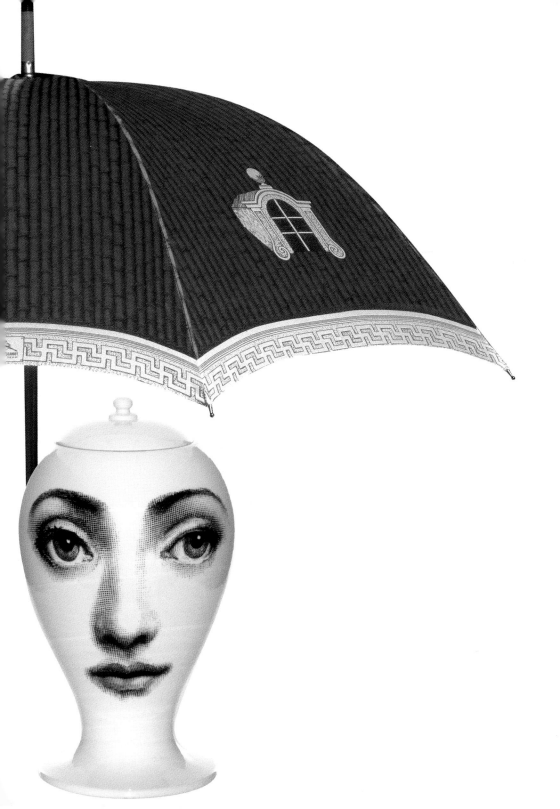

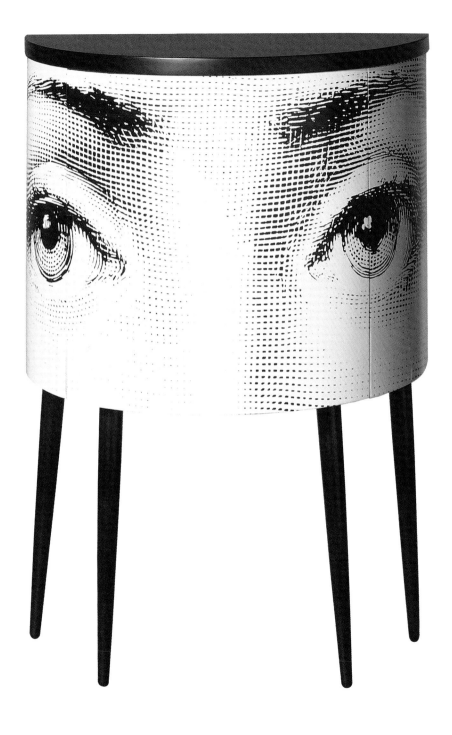

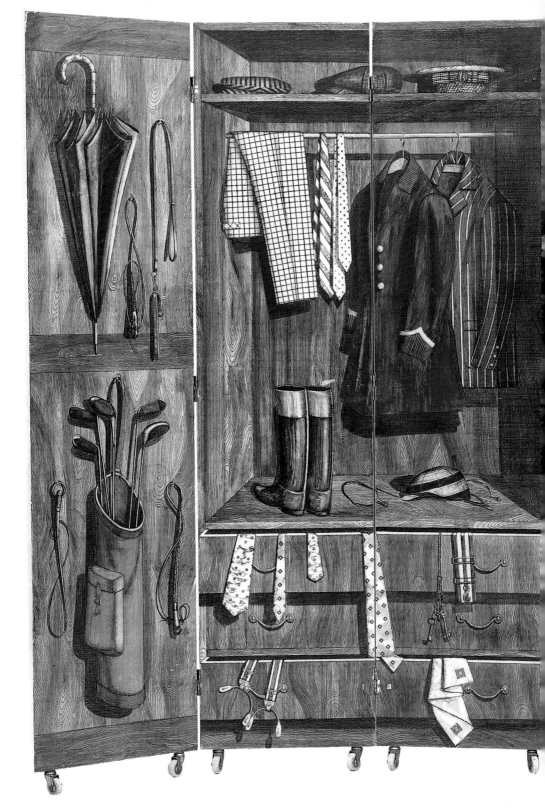

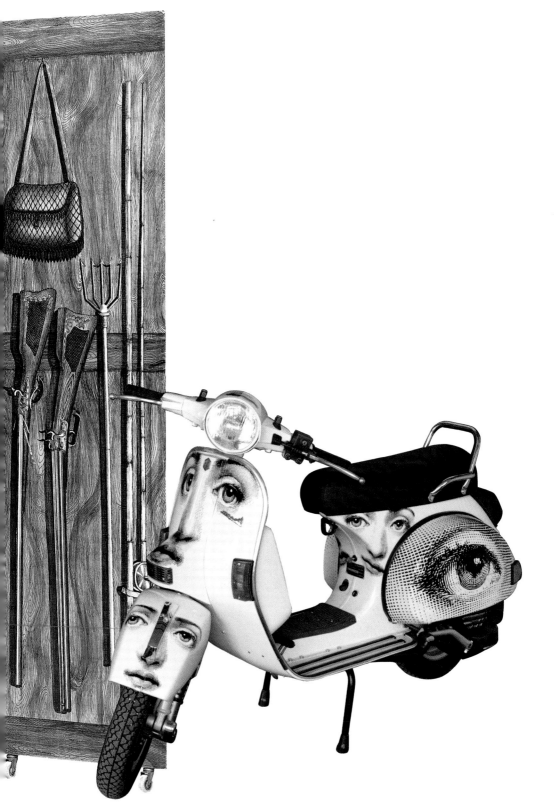

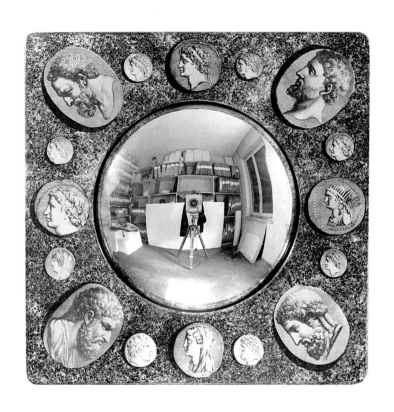

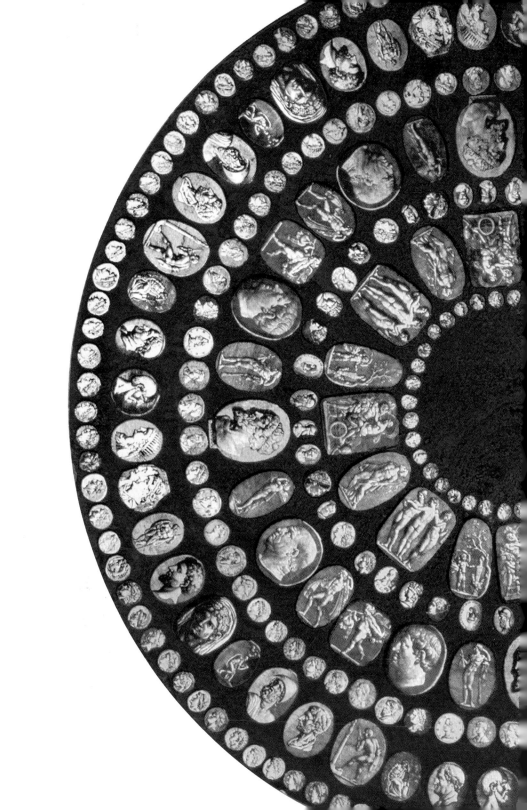

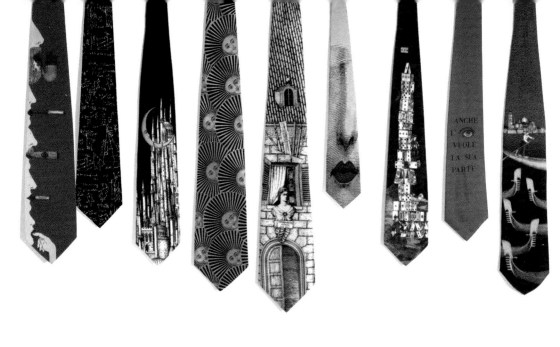

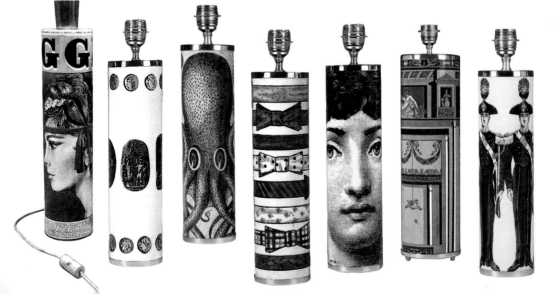

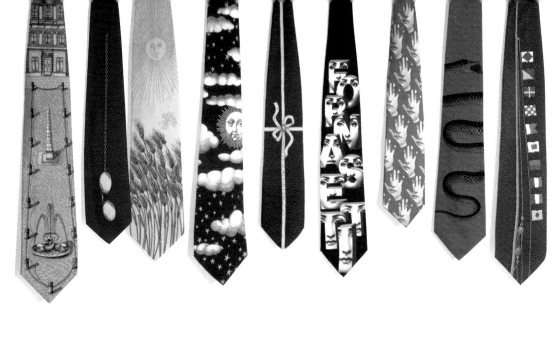

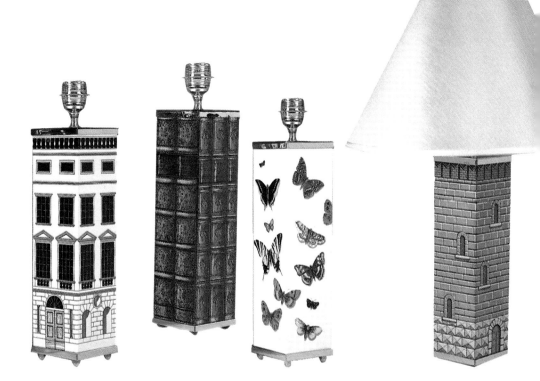

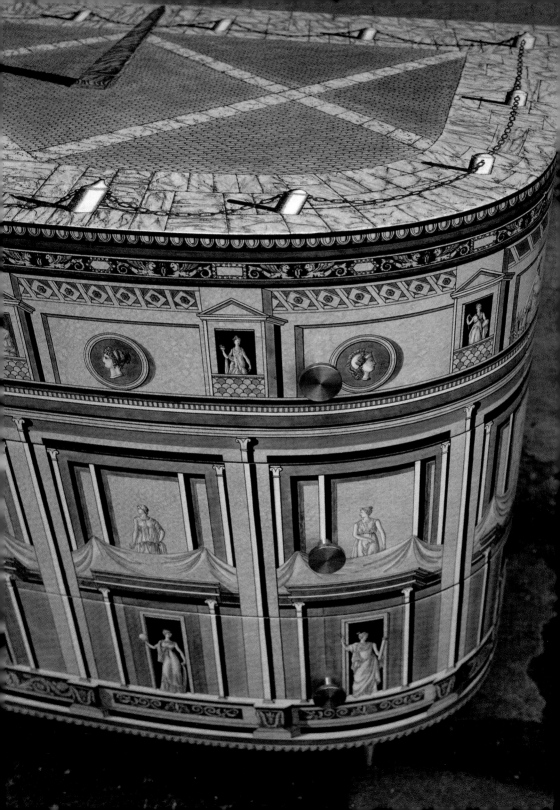

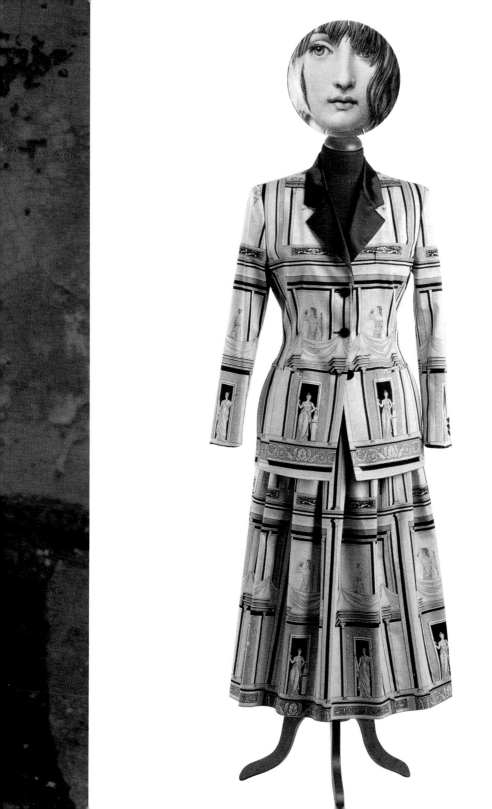

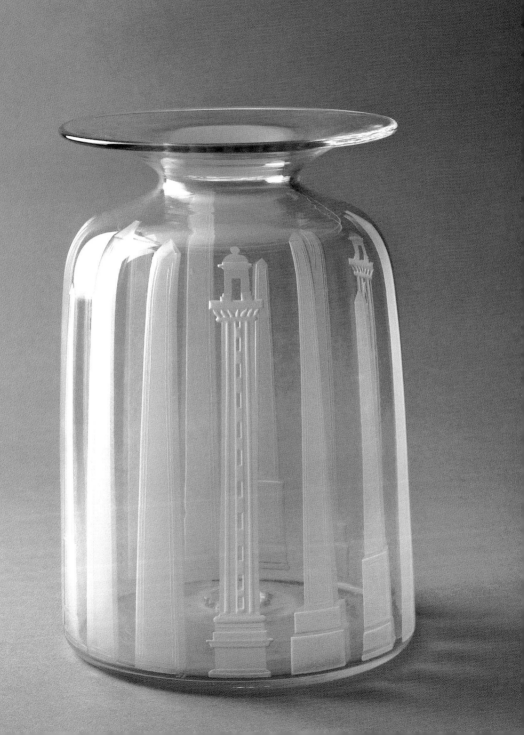

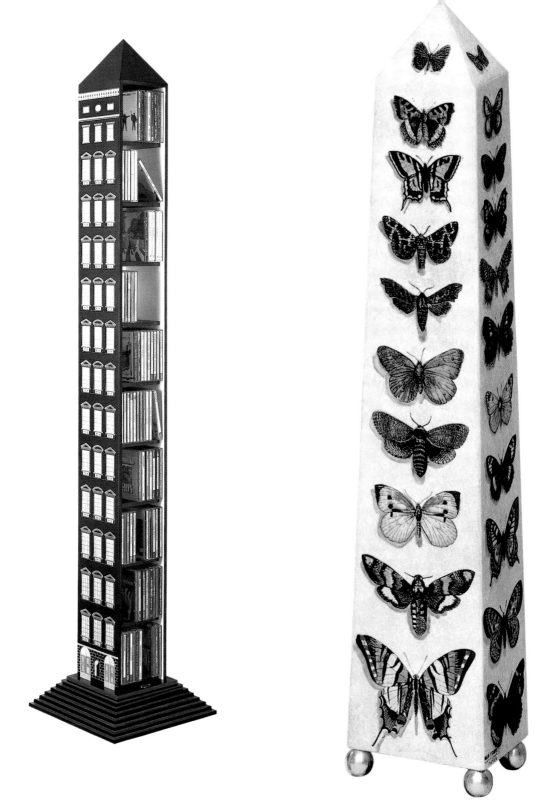

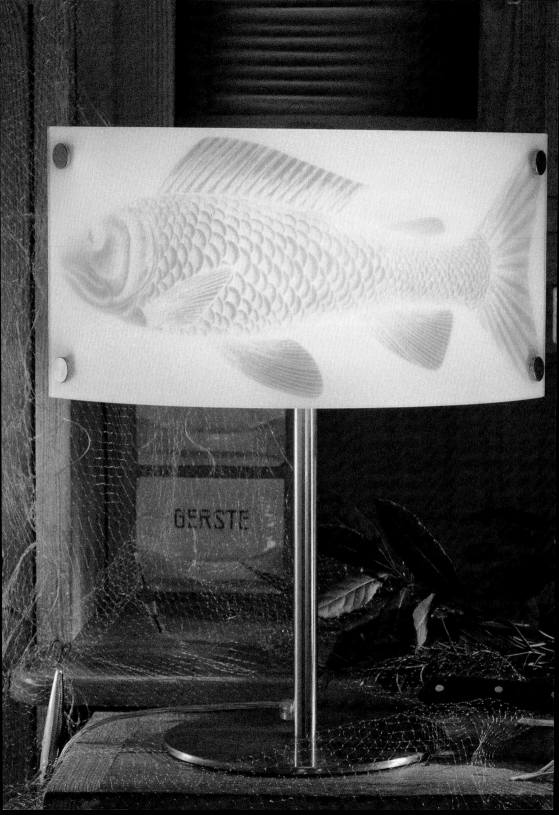

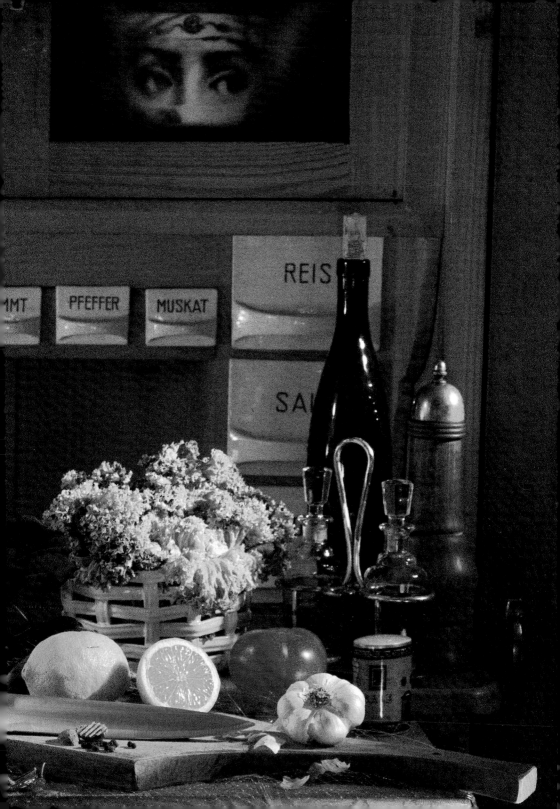

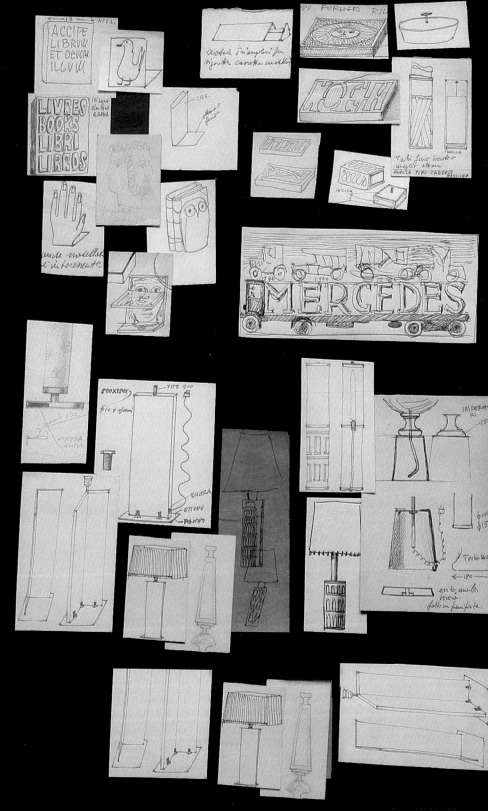

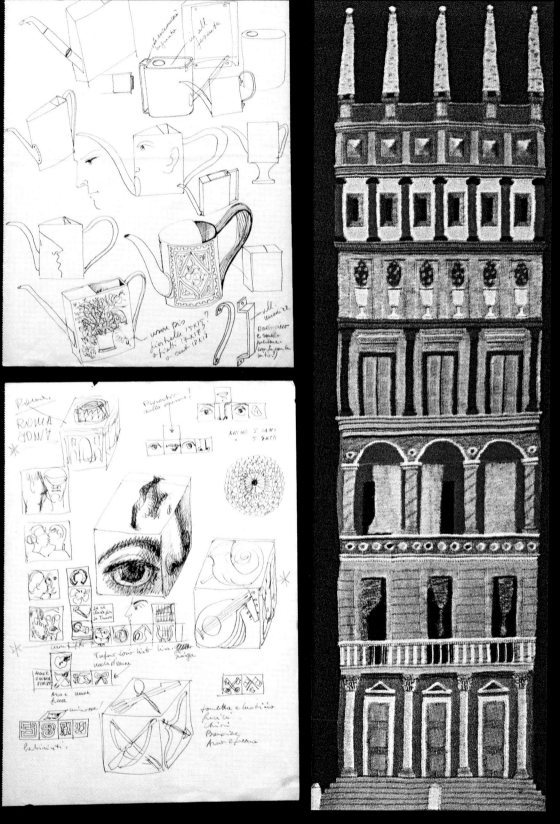

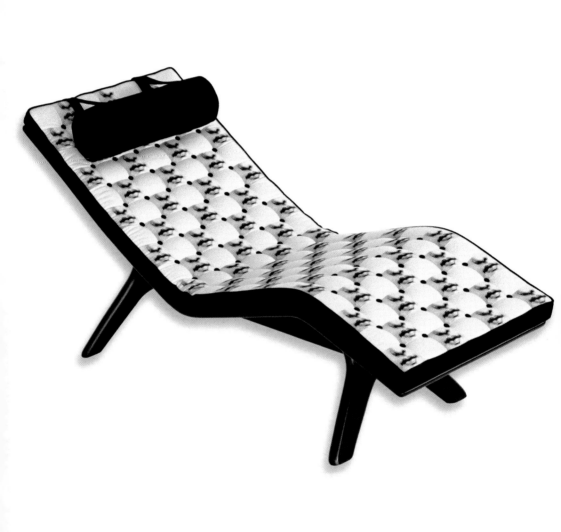

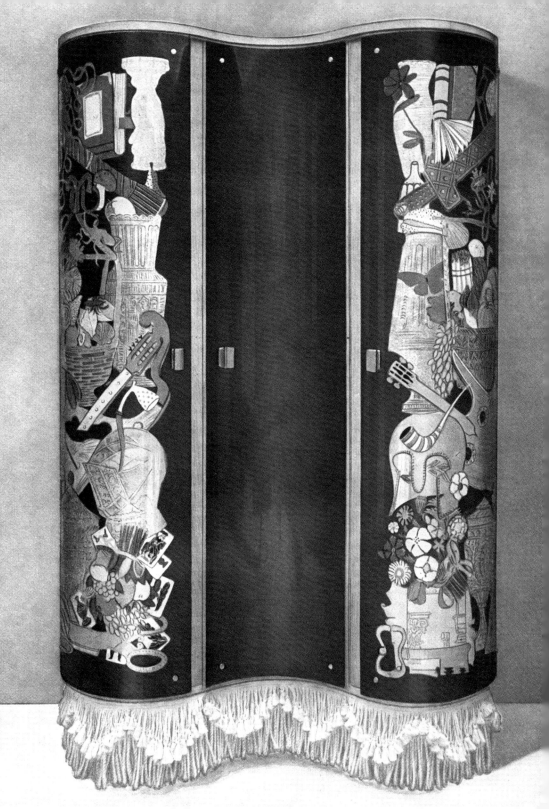

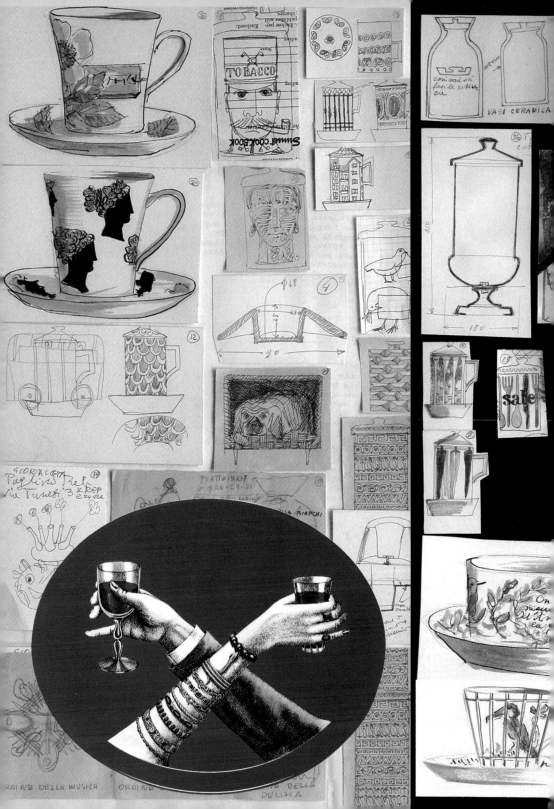

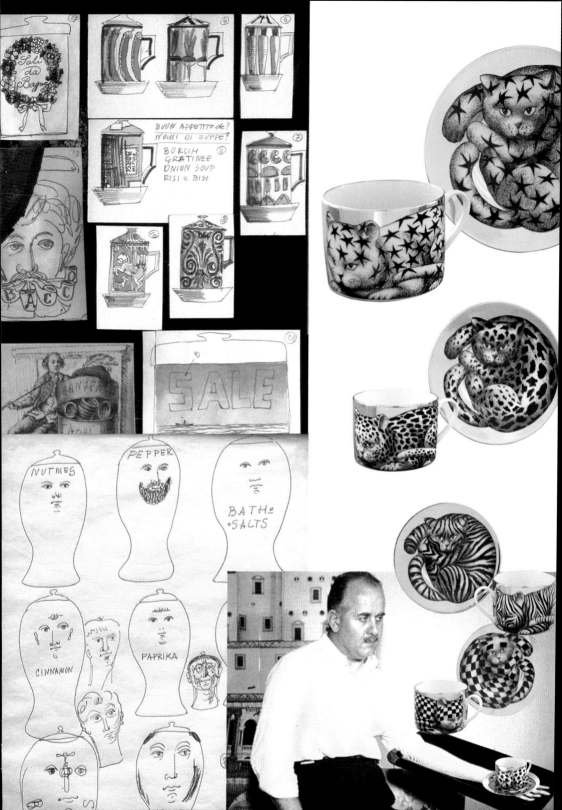

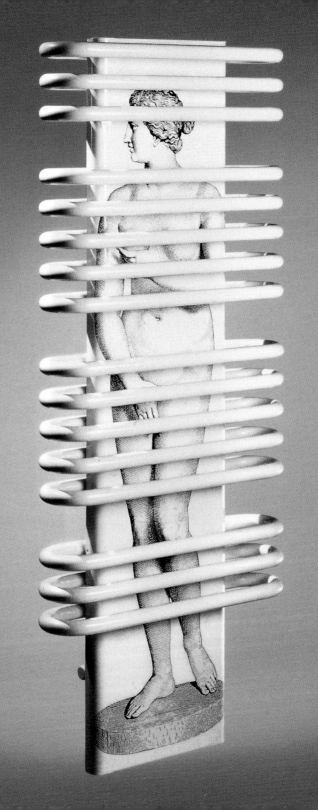

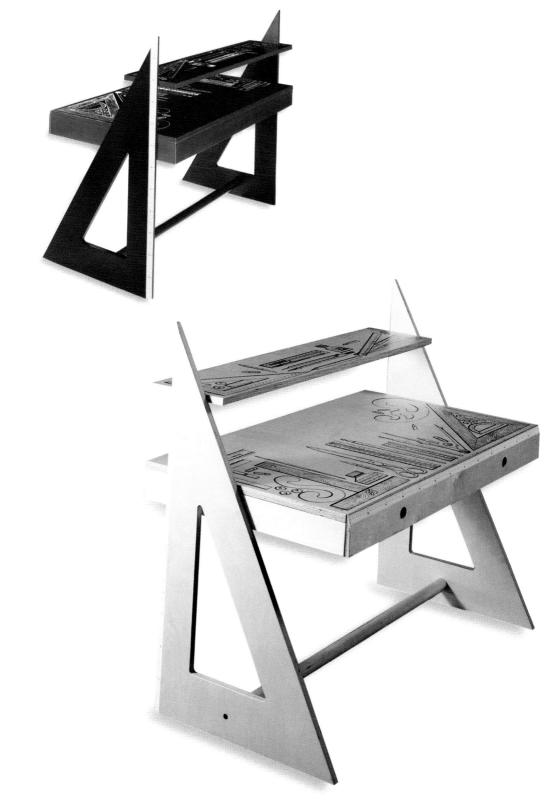

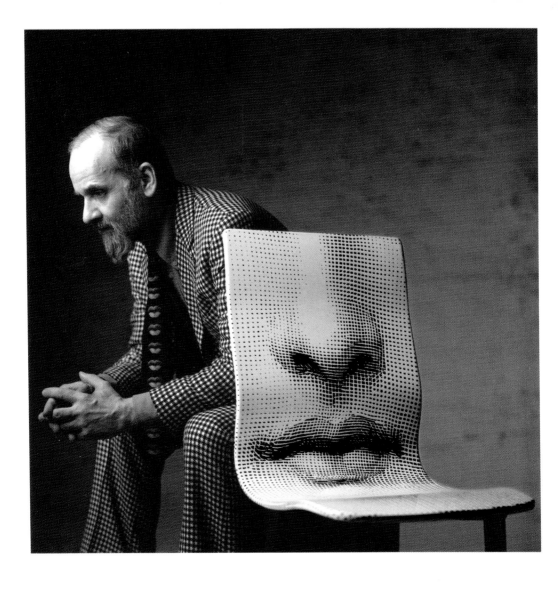

Chronology

1913: Piero Fornasetti is born on November 10, in Milan, into a wealthy bourgeois family.

1930: He enrolls in the Accademia di Brera in Milan to study drawing.

1932: He is expelled from Brera for bad discipline and enrolls at Milan's municipal Higher School of Industrial Arts.

1933: He presents his first canvases at the University of Milan during a group show of work by students. He takes part for the first time in the Milan Triennale, where he exhibits a series of scarves in printed silk.

1935: At the Sixth Milan Triennale he presents a bronze stele and decorative ceramic frieze in the archaic style.

1935–1955: As a printer of lithographs, Fornasetti produces works by some of the finest artists of the twentieth century (De Chirico, Fontana, Manzù, Sironi, Sassu, Campigli, Clerici, Tambur, etc.).

1940: At the Seventh Milan Triennale he meets Gio Ponti, who will regularly publish Fornasetti's works in the magazines *Domus* and *Stile*.

1940–1942: He designs the *Lunari* for a commission from Gio Ponti.

1943–1946: He takes refuge in Switzerland, where he designs posters and lithographs for magazines as well for the theater.

1946: He returns to Milan and designs a store with Clerici on the Via Montenapoleone.

1947: At the Triennale he exhibits a series of decorative motifs for ceramics (commissioned by Gio Ponti).

1949–1952: He designs a number of public interiors with Gio Ponti: the transatlantic liners Andrea Doria and Conte Grande, the casino at San Remo, the Arlecchino cinema, the Duomo hotel, and the Dulciora patisserie in Milan.

1950: He makes the prototype of the Trumeau.

1951: The studio on the Via Bazzini in Milan expands. He starts producing limited editions of furniture and decorative objects.

1954: He opens his first boutique on Via Manzoni in Milan.

1958: He opens the showroom on the Via Montenapoleone. More than eleven thousand objects will be exhibited there.

1959: He wins the Neiman Marcus Award in Dallas.

1968: He opens the boutique on the Via Brera in Milan.

1970: He and a group of friends run the Galleria dei Bibliofili (bibliophiles' gallery), where Fornasetti exhibits both his own work and the work of contemporary artists.

1979: Death of Gio Ponti.

Barnaba Fornasetti, 2000. "Bocca" chair (mouth). © photo Sandro.

1979–1982:	Pieces by Fornasetti fetch record sums in international auctions.
1980:	The opening of the *Tema e Variazione* boutique in London revives interest in Fornasetti's work.
1982:	Start of the collaboration between Piero Fornasetti and his son Barnaba.
1986:	Reorganization of the archives.
1988:	Piero Fornasetti dies on October 15 in Milan, after an operation in a hospital.
1989:	Barnaba Fornasetti continues the studio's activity by reissuing Piero Fornasetti's most famous objects. He also produces new prototypes.
1990–1998:	Barnaba works for the first time with other companies. He establishes licensing agreements and designs new objects whose decoration and applications are taken from the Fornasetti archives. These "reinventions" are manufactured in the studio.
1991–1992:	The Victoria and Albert Museum in London organizes a major Fornasetti retrospective. The first monograph is published on the same occasion.
1992:	The second major exhibition dedicated to Piero Fornasetti is put on at the Palazzo Ruspoli in Rome. Barnaba Fornasetti works with Laurence Steel to design a number of small collections of clothes.
1996:	The historic boutique on the Via Brera closes. Another one opens on Via Manzoni.
1998:	Christie's holds a Fornasetti auction in Los Angeles and notches up a series of record prices.
2002:	Barnaba Fornasetti calls on the architect Nigel Coates and together they produce the *Tête-à-tête* collection. Exhibition at the Palais-Royal, Paris, of 69 Erotic Drawings.
2003–2004:	Touring exhibition organized by the Italian cultural institutes in Chicago, Washington, San Francisco, Toronto, and Los Angeles.
2004:	The Architettura trumeau is cited in the journal *Antiquariato* as the archetype of twentieth-century furniture.
2005:	The Fornasetti studio continues to develop and, with its guest apartment, becomes almost a living museum.

"Raggiera" (Rays) chairs, 1950s, reissued in color in 2001.
Sketches and ideas by Piero Fornasetti, 1950-60.

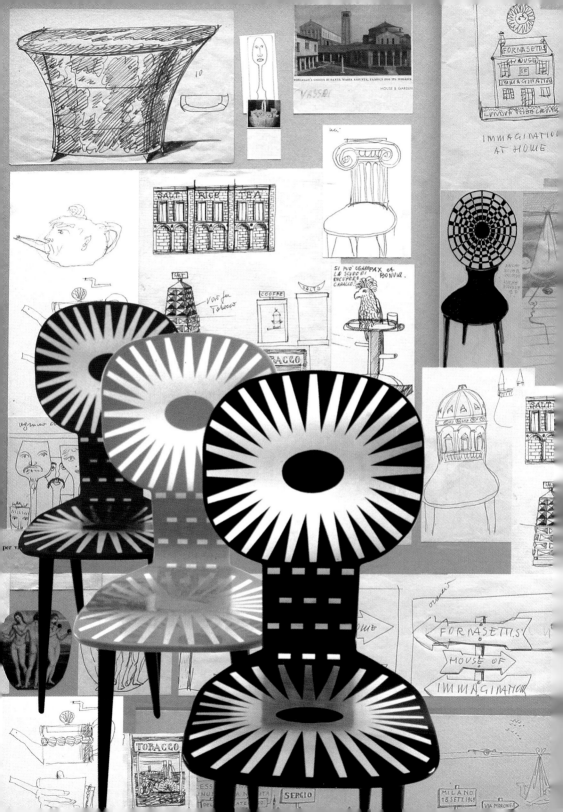

Piero Fornasetti

Chair with back in the form of a Corinthian capital, 1950s.
"Architettura" (architecture): first version of the bureau bookcase based on a design by Gio Ponti. © photo Marco Pratali.

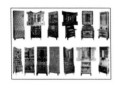

The main versions of the cabinet or bureau, from the first version inspired by Gio Ponti to Barnaba Fornasetti's "Fine Millennio" (End of Millennium) model and the black "Architettura" version of 2004.

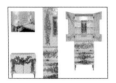

"Panoplie" bureau, 1950s. © photo Galleria Nilufar.
The Empire style revisited by Fornasetti for a bedroom.

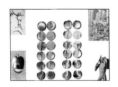

From top to bottom, from left to right: **Erotic drawing, 1943. Apple,** pencil drawing, 1970s. Set of twelve **"Adam and Eve"** plates, 1950s (diameter: 26 cm). **"Armadio surreale"** (Surreal Wardrobe), drawing, 1950s. **"Atleta"** (Athlete), a rare example of a Piero Fornasetti sculpture, 1936.

Tête-à-Tête. Nigel Coates and Barnaba Fornasetti, 2002. First example of collaboration with an architect based on Piero Fornasetti's work with Gio Ponti. Decorated or silkscreened chairs, vases and lamps revisit some great Fornasetti classics: Adam and Eve. © photo Marco Pratali.

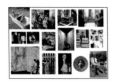

Piero Fornasetti: drawing in his bathtub; with Gio Ponti and friends, 1950; at an exhibition with Jiulia, 1947; printing, 1953; checking lithographs, 1943; working on panels for the Arlecchino cinema; behind one of his Venetian blinds, 1964; spraying color onto a scarf with Jiulia, 1943; with clients, 1954; in the "Stanza Metafisica", 1958; with some early paintings, 1928; in 1982; in 1984; in 1982; with "Pranzo in Piedi," 1983. © photos U. Mulas, H. Grey and Farabola.

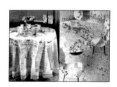

"In Cartoccio" 1953. The same motif is applied to the table cloth, the flatware, the plates, the glasses and even the flowers. Photo published in *Domus*, the magazine founded by Gio Ponti in 1923. (© photo Dainesi). Elsa Schiapparelli handbag decorated by Piero Fornasetti.
"Ultime Notizie" decoration for a Milanese apartment. The butterflies symbolize the airy nature of this "Latest News." © photo Guy Hervais.

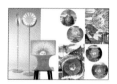

"Sole" (Sun) standard lamps, 1990s; chair, 1950s.
"12 mesi 12 soli" (12 Months, 12 Suns): plates, 1950s (diameter: 26 cm). Two pictures from the "Lunario" (Solar Almanac), 1942.

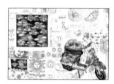

"Sole di Capri" (Capri Sun): headscarf drawing and magazine rack, 1950s; Vespa prototype, 2000. (© photo Massimo Zarucco).

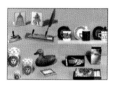

Creations from 1950s-60s (from top to bottom and left to right): bookends, penholders, ceramic jars, "Duck" terrine, cups and saucers, cigarette boxes in lacquered aluminum with mahogany lining.

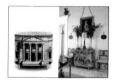

"Palladiana" chest of drawers, 1953 (100 x 56 x 86 cm).
"Leopardo" (Leopard) chest of drawers (100 x 56 x 86 cm) designed by Piero Fornasetti for his own use. Above it hangs a self-portrait. Villa de Varenna, Lake Como, 1953. © photo Alberto Zabban.

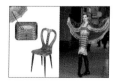

Scala di Milano: tray with the interior of the famous Milanese opera house, 1950s (48 x 60 cm); umbrella, 1999; lyre-backed chair, 1950s; dress from a collection by the designer Laurence Steel, 1993.

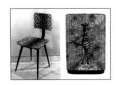

"Boomerang" chair with leopardskin decoration, 1950s. © photo Farabola.
"Zebra" cabinet by Barnaba Fornasetti, 2003 (92 x 33 x 130 cm).

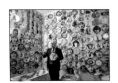

"Tema e Variazioni": Piero Fornasetti with his "Theme and Variations" collection of plates, 1961. The series was inspired by a female face (probably Lina Cavalieri), which it showed in constantly new and different perspectives. This theme harks back to the old tradition of decorating plates with the likeness of women's faces. © photo Roberto Barbieri.

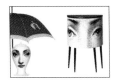

"Tetto" (Roof): umbrella by Barnaba Fornasetti, 1994. "Tema e Variazioni": new edition of a ceramic vase with the famous face, 2004.
"Occhi" (Eyes): console, revisited by Barnaba Fornasetti, 2001 (66,5 x 32 x 96 cm).

"Armadio aperto" (Open Wardrobe): screen, 1950s (200 x 200 cm).
"Tema e Variazioni": Vespa, prototype, 2000. © photo Massimo Zarucco.

"Magic Mirror" with cameos, 1950s.
Table with cameo motifs, 1950s (diameter: 115 cm).

Neckties by Barnaba Fornasetti, 1993-2003.
Lamp bases, Piero Fornasetti, 1950s and 60s.

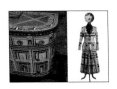

"Pompeiana" chest of drawers, 1990.
Skirt suit "Pompeiana" by Barnaba Fornasetti and Laurence Steel, 1993. "Tema e Variazioni" plate.

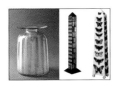

Engraved glass vase for SALIR, Murano, 1940. © photo Michele Sereni.
"Architettura" CD-holder, reinterpretation by Barnaba Fornasetti, 1997 (height: 165 cm). "Farfalle" (Butterfly) obelisk lamp, 1950s.

"Pesce" (Fish) lamp, 2002. © photo Marco Pratali.

Ideas and sketches by Piero Fornasetti, 1950s–1970s.
"La casa ideale" (Ideal House), 1940.

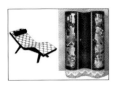

"Bacio" (Kiss) lounge chair, reinterpreted by Barnaba Fornasetti, 2004. © photo Marco Pratali.
Wardrobe in molded glass, with appliqué gold and silver leaf, designed by Gio Ponti and decorated by Piero Fornasetti for Fontana Arte. One of the first collaborative works by the two designers.

Sketches and plans for ceramic objects, 1950-1960. "Brindisi" tray, 1950s.
"High Fidelity" tea service. Piero Fornasetti with the "Mano con moneta" (Hand with Coin) tray, 1959.

"Venere" (Venus) heated towel rack, 1995.
"Riga e squadra" (Ruler and Set Square), bureau bookcases reinterpreted by Barnaba Fornasetti, 1998 (130 x 79 x 120 cm). © photo Massimo Zarucco.

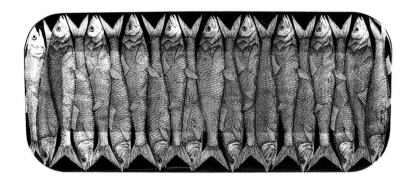

Above: "Sardine" tray, 1950s (25 x 60 cm).

The publisher would like to thank for their precious collaboration Atelier Fornasetti, and especially Barnaba Fornasetti, Yuki Tintori and Nadia Boni, as well as Philippe Starck. We are also grateful for their kind participation to Antonangeli, Ceramiche Bardelli, Nigel Coates, Della Vedova, Ceramiche Flavia, Intermoda, and Runtal.

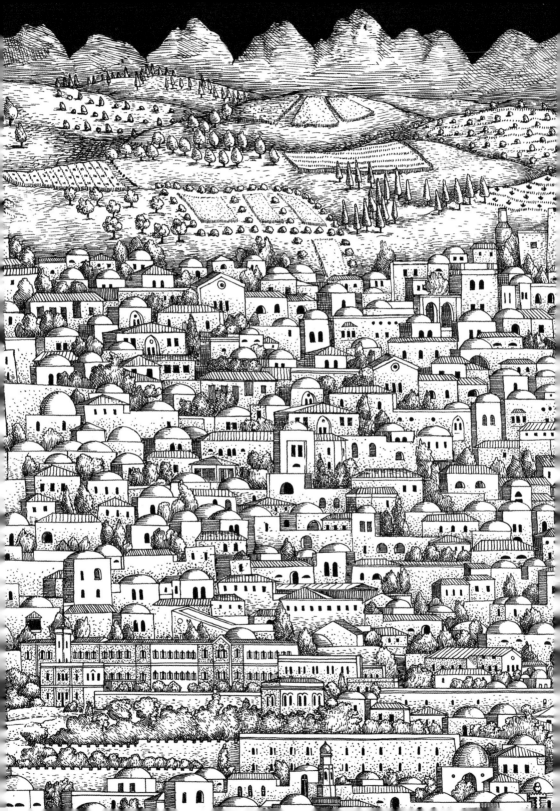